Robert **Capa** DESIGN

D1492878

Robert **Capa**

Introduction by
Jean Lacouture

Thames & Hudson PHOTOFILE

*The Photofile series is the original English-language
edition of the Photo Poche collection. It was conceived and
produced by the Centre National de la Photographie, Paris.
Robert Delpire is the creator and managing editor of the series,
in collaboration with Benoît Rivero, assistant director.*

First published in the United Kingdom in 2008 by
Thames & Hudson Ltd, 181A High Holborn, London WC1V 7QX

www.thamesandhudson.com

First published in 2008 in paperback in the United States of America by
Thames & Hudson Inc., 500 Fifth Avenue, New York, New York 10110

thamesandhudsonusa.com

Photo Poche © 2008 Actes Sud, France
Photographs © 2008 Cornell Capa
This edition © 2008 Thames & Hudson Ltd, London

British Library Cataloguing-in-Publication Data
A catalogue record for this book is available from the British Library

Library of Congress Catalog Card Number 2008902997

ISBN: 978-0-500-41066-0

Printed and bound in Italy

TOWARD PHOTO-HISTORY

Legendary—how to avoid this word so often used to describe Robert Capa? Like that of the actor, the profession of pursuer of pictures, and facts, is fraught with an onerous and sometimes demeaning mythology. With the exception of Molière, however, few actors have died onstage, whereas countless photographers—Capa foremost—have given their lives in an effort to get a firmer grip on the truth.

The legend of the founder of Magnum Photos is more than a tale of office girls and shutterbugs. We who have gone the same route, who have "followed the leader" (like Brassens's little pony), have made of this story an inspiring myth. After all, why shouldn't we dare what he dared? Why shouldn't we ourselves try to capture what he captured—in Spain, China, and Sicily, during the Normandy invasion, and in Indochina?

Of course, the man with the camera in his hand faces far more rigorous imperatives than the pen-pusher. His highest credo—"being there"—is both more tyrannical and more all-consuming than ours. He must get closer, ever closer...and indeed, Capa's greatest scoops imply a dizzying proximity. (It's no accident that the two people dearest to him, Gerda Taro and David "Chim" Seymour, died exactly as he did.) For those of us hiding behind our little pads and pencils, Bob Capa's example has proved both thrilling and seductive. He spurred us forward, prodded us ever onward toward the truth. This man, whom I never had the pleasure of knowing personally—my assignments in Indochina came before and after his tragic death in 1954—has been a compelling motivator, not only in my life but in the lives of so many others, perhaps even more after his death than during his lifetime.

André Friedmann was born in 1911, to a middle-class family in Budapest (I wonder if we've sufficiently acknowledged photography's debt to Hungary, from Kertész to Brassaï, Munkacsi to Capa,

and so many others?). He was a good student, a high-strung adolescent involved in revolutionary political groups inspired by Lajos Kassák. For a young and exuberant Jew, these were difficult times, anti-Semitism being the rule rather than the exception. In 1931, André was forced to flee to Berlin, where he was taken in by another Hungarian, Simon Guttmann, the founder of the Dephot Agency (Deutsche Photodienst) and the father of modern photojournalism. At that time, there was no waiting for André to prove himself; he was immediately sent to Copenhagen, where Trotsky, with Stalin in hot pursuit, was to give a speech. From that moment, Capa lived with a camera in his hand, even when the advent of Nazism forced him to leave Berlin.

He fled, of course, to Paris, to the Montparnasse of the 1930s, and was instantly seduced. The fierce nomad, the traveler always camping out in temporary quarters, the wanderer who would never have a favorite hotel in New York or London or Hong Kong, fell in love with Paris, which was at the time—if we're to believe Hemingway—a movable feast. One must remember, however, that to see Paris as a perpetual party was harder for a Hungarian refugee than for an American writer; the fate of Jews from Eastern Europe, who lived under the watchful eye of Monsieur Chiappe's police, was not an enviable one.

The newcomers supported one another and created organizations for mutual aid. During one of their meetings, André met a small and rather delicate man, shy but jovial, his eyes hidden behind thick spectacles, a Pole by the name of David Szymin. They immediately struck up a friendship, and a pact was sealed between the daring Hungarian loner with the velvet-black eyes and the skinny student from the Orthodox Jewish community in Warsaw, the latter haunted by the tragic fate of the Jewish people, the former proclaiming cheerfully that no curse exists that cannot be swept away by courage and an enterprising spirit.

This wonderful alliance with "Chim," a partnership that gave André's short and violent life a halo of human gentleness, would be followed by five crucial discoveries: Gerda, Henri, the Leica, the war, and—"Robert Capa".

Gerda Taro was a twenty-year-old German student, slender, blond, and a fearless anti-Fascist. She was the great love of André's life and the best of his colleagues, but would die young in Spain, crushed by a Republican tank on the Brunete Front. André never

really recovered from the wrenching anguish of her death; his first book, *Death in the Making*, about the war against Franco, was signed by both of them.

A few years after their friendship began, Chim introduced André to the Dôme, the café-restaurant in Montparnasse where Anaïs Nin gazed soulfully into Henry Miller's eyes and Aragon read aloud to Philippe Soupault from *Le paysan de Paris*. On certain nights, Chim and André were joined by a tall young man with a high forehead, a bold look, and a voice filled with passion; this was Henri Cartier-Bresson, still straddling the fence between Surrealism and intergalactic adventure, Cubist painting and his camera. With one stroke, the little Polish refugee forged an alliance between the decade's two most antithetical pursuers of the image—movement and structure, nature and culture—a partnership as improbable as that of the torrent and the rock.

The formation of this trio, brought together so magically in Montparnasse, might not have proved so fruitful, however, had it not been for the timely appearance of the Leica, the perfect instrument for the venture they were just beginning to formulate. The Leica had been adopted only recently by André Kertész, but would prove to do for photojournalism what Guibert's invention of the division did for Napoleon. An extension of the arm, friend of the eye, perfect for the direct, fast, and surreptitious glance, creator of lines and inventor of visual understatement, the Leica transformed the trio conceived at the Dôme in 1934 into a quartet.

All that remained was the right occasion, the chance to prove, with a brilliant display, the power of this new instrument to capture life. The opportunity presented itself in 1935, first in Ethiopia and Manchuria, then in Spain, and then in the great French popular demonstrations of 1936, when the frenzied world offered photojournalism an incomparable booty in the form of chaos, madness, martyrdom, and *opéra-bouffe*.

André's fifth conquest was "Robert Capa." The origins of this pseudonym are unclear; perhaps the Hungarian word for "sword," or the Spanish word for "cape," or "disguise," or even the slightly altered name of the great director Frank Capra, whom André admired above all others, according to his biographer, Richard Whelan. In any case, it seems a perfect pseudonym—international, pronounceable in all languages, a name André cleverly used in his role of the "great American photographer," referring to "Fried-

mann," in Paris, as his representative while speaking glowingly, as Capa in New York, of his "friend André."

It was Capa then, Bob Capa, whose photographs of the Spanish Civil War spread like wildfire around the world. The most famous shot any photographer had yet taken with his little black box appeared in 1936, the photo of a Republican soldier in white work-clothes, pale as Cocteau's angel, falling backward, struck down on a hillside, his rifle blown from his grasp by the fiery breath of death. Even when people no longer know anything about this war or what it meant for the future of the world, they will still stare, trans-fixed, at this incredible image. All our writing may vanish, like the hieroglyphics after Emperor Theodosius's interdiction, but this pho-tograph will remain a sort of ideograph of the war.

During the summer of 1938, just after the death of Gerda, the now-famous Capa found himself in China. Simon Guttmann, Capa's former patron from Berlin who had also fled to Paris, had organized the operation, forming a pool which included *Life* maga-zine, Agence Pix, and the pro-Communist weekly *Clartés*. Capa wrote from Hangchow to an old Hungarian friend; he could no longer endure his present situation, the way Guttmann treated Capa's talent, his trips, his very life, as his own property. Out of this discontent came the idea of smashing the tyranny of the "bosses" and the newspaper cartels by creating a cooperative agency, to be formed by Capa, Chim, and Cartier-Bresson. Here, Capa was clearly influenced by his experience with the Popular Front, which saw the flowering of so many cooperatives, including the one evoked by Jean Renoir in *The Crime of Monsieur Lange*.

In his memoirs, Capa wrote that he found himself in New York at the end of 1942, out of work and up to his ears in debt. One morning, between the rent and telephone bills that had been slipped under his door, Capa found a letter from *Collier's* magazine offering him the chance to cover the war in Europe. Eighteen months later he emerged from the blood-soaked dust of Tunisia, the chaos in Sicily and Rome, the waves of troops landing on the beaches of Nor-mandy, and found a Paris laughing through its tears, a Paris corrupted but free, defiled but marvelous, a summertime Paris, war-torn but feverish with joy. He entered the city, to great adulation, at the head of a host of friends—John Huston, William Saroyan, Irwin Shaw, George Stevens, Ernest Hemingway—followed soon after-ward by Chim, now known as Seymour, and expecting Cartier-

Bresson to leap out at any moment from behind some barricade or other.

Robert Capa was now thirty-three. To have an idea of what he must have been like during those prodigious times at the Dôme or at the bar of the Ritz, requires us to imagine someone with the energy of Joseph Kessel, the swagger and audacity of Errol Flynn, the sparkling fantasy of the young Yves Montand, and the cheerful compulsiveness of Ernest Hemingway. In Robert Capa, people saw the character who inspired Clark Gable, the reporter-hero in *Too Hot to Handle*, which was shot on the eve of the war. (What a marvelous Capa Robert de Niro would make today!)

Saroyan described Capa as "basically a poker player who took pictures on the side." Throughout Africa, Italy, France, and the Ardennes, however, he captured more moments of life and death with his camera than any man of his time, and this without loving any fewer women or losing any less money at cards than those who competed with him for the number-one slot. He was fearless, insolent, and extravagant. He seemed to live with more intensity than anyone else, capturing the heart of Ingrid Bergman, among others.

Capa's 1938 Hangchow dream of a cooperative agency became reality in April of 1947, in the restaurant of the Museum of Modern Art in New York. The founding members were Robert Capa, Henri Cartier-Bresson, Chim Seymour, George Rodger (not present at the MoMA meeting), and William and Rita Vandivert, who left the group soon afterward. On May 22, 1947, Magnum Photos received a commercial license from the city and was ready for business.

Where did that proud and noble Roman name, Magnum, come from? Among a dozen other associations in Capa's mind, the word Magnum evoked the word champagne. Every one of the agency's innumerable successes had to be celebrated, at least until the founder's death, with the pop of one of those voluptuously shaped bottles.

The question remains as to why these men chose to form a co-op. When the idea first came to Capa in China, these photojournalists were still on salary but already famous. Throughout the war, they continued to prove their masterful superiority, and were clearly in a position to challenge the dictates of the press bosses. Why then did they opt to create an organization that by definition would impose all sorts of other demands—the pooling of their work, the adminis-

tration of a collective patrimony—on this group of individualists, these lone wolves plying the trade of photojournalist?

In response, Romeo Martinez explains: "Capa's idea—specifically, that the journalist is nothing if he doesn't own his own negatives—will prove to be the sanest idea in the history of photojournalism. The co-op is the best formula for retaining those rights, and for ensuring the freedom of action of each of its members."

The creation of Magnum in 1947 changed nothing in Capa's life style or professional activities. In his role of co-op "president" he supplied most of the grist for the mill, coming up with a dozen ideas an hour, scolding and hustling his associates, tossing out constant challenges, bluffing, provoking, exasperating, endangering the very existence of the agency with his gambling debts and lavish expense accounts, then rescuing it with some new feat of derring-do, or simply with his genius for business. In fact, with every passing day Capa seemed more impatient to surpass his fame as a devourer of images, of risks… and of women. "A gambler? Perhaps. But at least he's not a cheater!" said Marc Riboud, who worked closely with him at the time and knew him well. Indeed, at the height of his fame Capa seemed to be everywhere—in Israel with Irwin Shaw, in Poland, in Morocco, shooting portraits of Picasso, Matisse, the Aga Khan, Eisenhower.

For seven years, men had been dying in Indochina for reasons no one seemed to understand very well. Capa's problem was not so much the why but the how. He despised war; it had taken Gerda from him, as well as many of his friends, not to mention most of his illusions. Yet the war was an integral part of his world, and the source of his fame. How could he let the war in Indochina run its course without taking a look at it? His friends at Magnum warned him: Why be in such a hurry to leave? They asked. And did he really want to impose that trial upon himself? The answer was yes, and when Capa boarded a plane for Saigon in the spring of 1954 it was neither an act of bravado nor a moment of thoughtless caprice.

The month of May found him in Hanoi. The fall of Dien Bien Phu came on the seventh, but the fighting continued. Capa decided to join a contingent headed for Thai Binh. On the twenty-fifth, he left the road in order to get a clearer shot of the soldiers and stepped on a mine. He died a few minutes later, one leg blown off. His mother vetoed the honors proposed by the French army to commemorate

his death; there would be no military homage for this man who despised war.

If the photograph is life, then Capa was photography. In fact, for him photography was more than that, which was why he needed Chim's conscience and Cartier-Bresson's sense of aesthetic structure. Yet Capa's contributions—motivation, energy, imagination—were no less vital to Magnum's success, or to the growth of modern photojournalism.

Had it not been for fascism and the war, André Friedmann, nicknamed "Bandi," might have been an energetic young businessman from Pest. Or the founder of a shipping company on the Danube, or an orchestra, or a theater in Buda. Whichever, he would surely have astonished the world he lived in and shaken up the world at large.

What he shook up, indeed turned upside down, was the act of photography. In freeing his friends at Magnum from the tyranny of the big magazines and agencies that had always owned not only their photographers' time but their negatives, Capa invented a wholly new method of giving chase to the image.

Early in 1954, Robert Capa told Marc Riboud that the development of television posed a real danger to photojournalism. This danger has now clearly been surmounted, despite the ongoing need for research and reconversion. If the reign of television has in any way altered the profession of photography, however, it is in the conquest of time and duration. Like their colleagues in the press, perhaps photographers will increasingly tend to detach themselves from the moment and concentrate on notions of permanence and sequence. And history—as progression, and as both a reshaping of the world and a struggle against forgetting. Like so many others since then, both Capa and Magnum, in their pursuit of photohistory, have pointed the way.

Jean Lacouture

Translated by Abigail Pollak

1. Trotsky's speech on the history of the Russian Revolution, Copenhagen, November 27, 1932.

2. Paris, 1936.

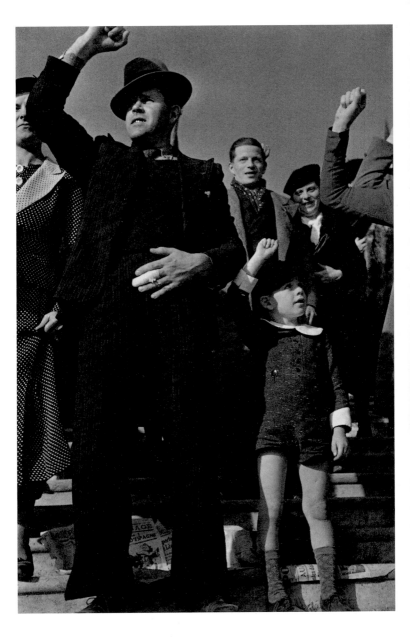

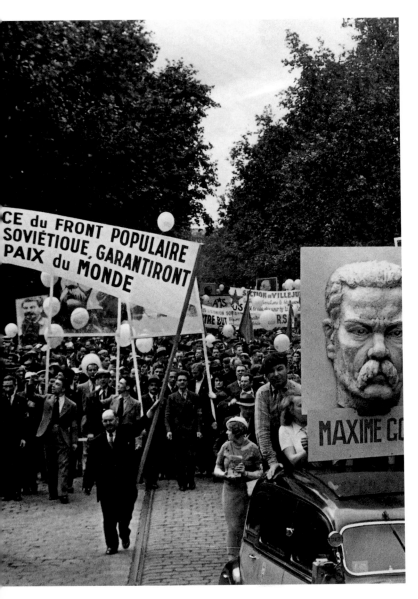

3. Paris, July 14, 1936.

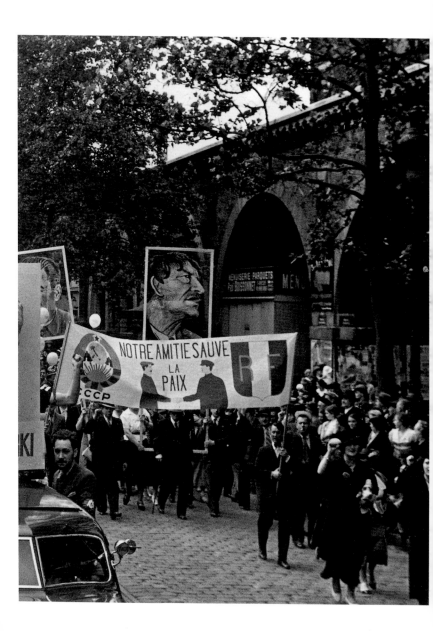

4. Under the portico of the Stock Exchange, Paris, Spring 1936.

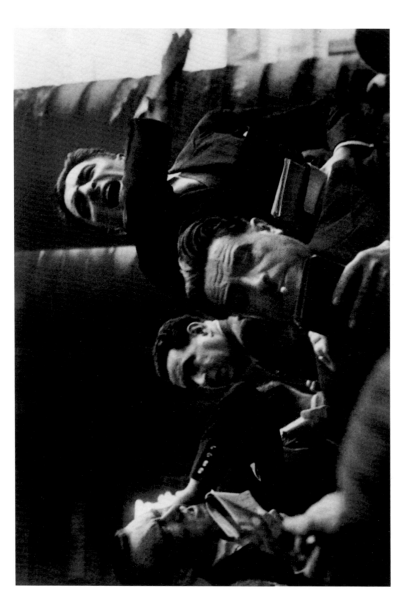

5. Paris, May 1, 1937.

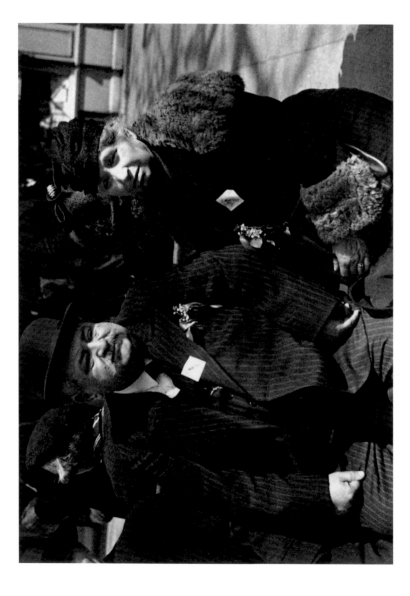

6. Veterans of World War I, France, 1936.

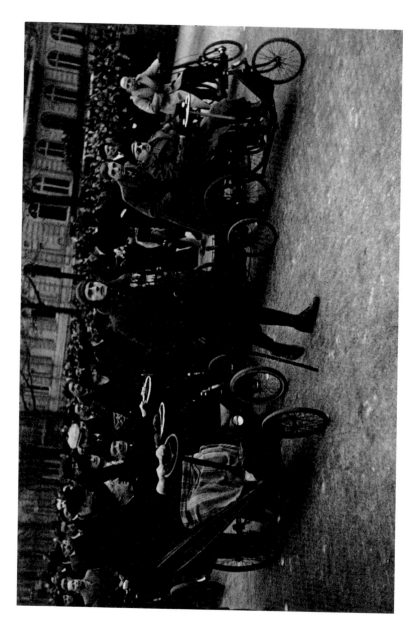

7. Veterans of World War I, Verdun, 1937.

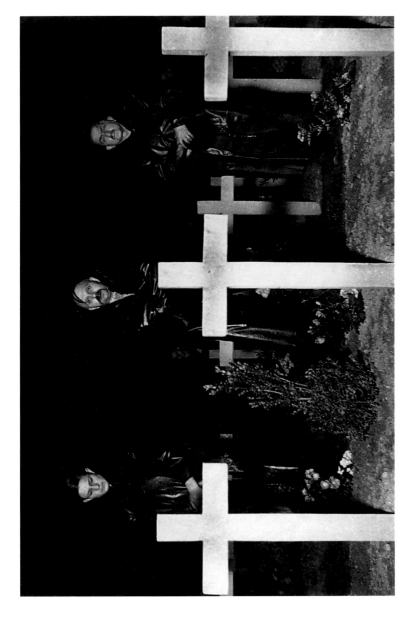

8. Madrid, July 1936.

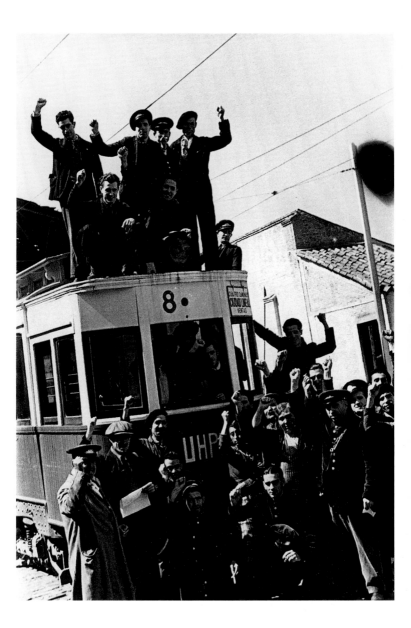

9. Spain, 1936.

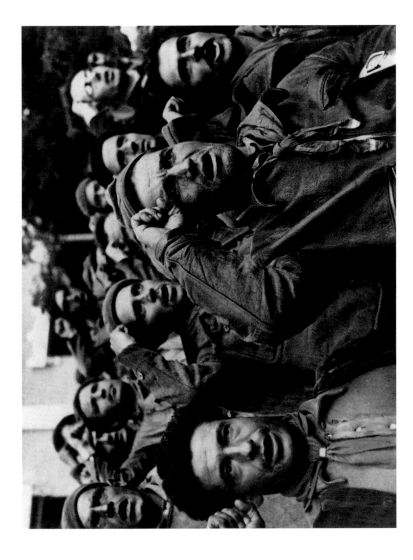

10. Spain, 1937.

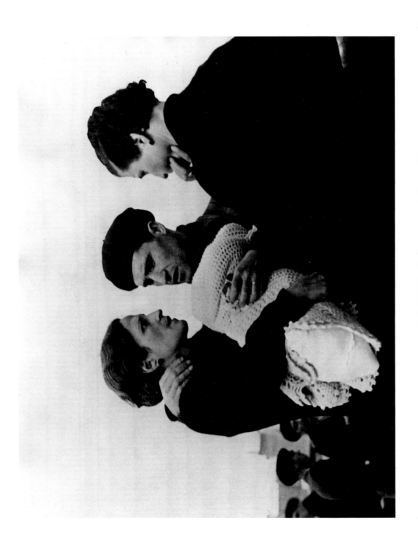

11. Spain, November 1936.

Overleaf:
12. Teruel, December 24, 1937.

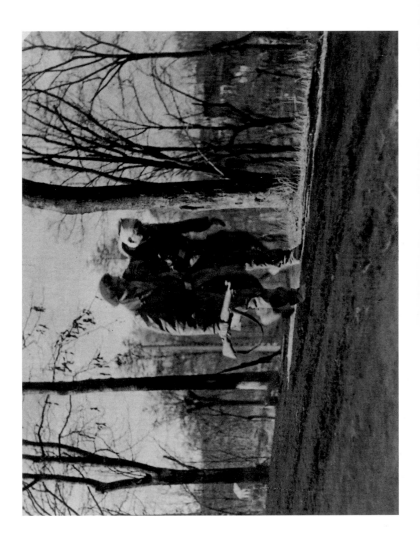

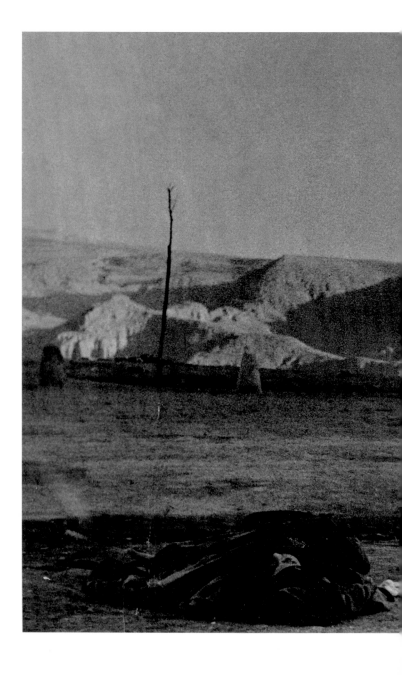

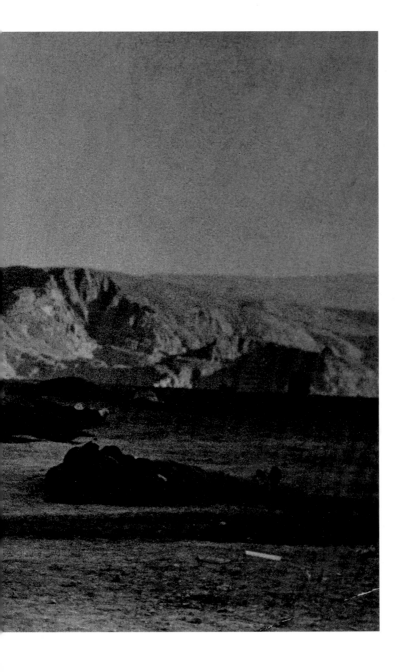

This image has often been hailed as the greatest war photograph of all time. It has also been subject to allegations of fakery.

The falling soldier has now been identified as Federico Borrell García, from the village of Alcoy, in southeastern Spain. The Spanish government's archives confirm that Borrell was killed in battle at Cerro Muriano on September 5, 1936.

It has also been proved that Capa took this photograph during the battle at Cerro Muriano, on September 5, 1936.

There can be no further doubt.

Richard Whelan

13. Death of a Republican soldier, Spain, near Cerro Muriano, about September 5, 1936.

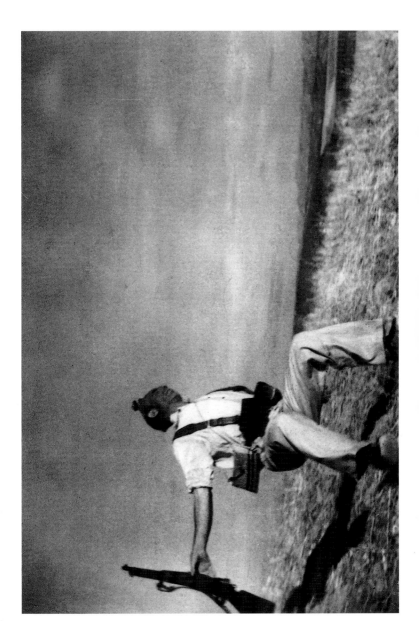

14. Spain, near Fraga, November 7, 1938.

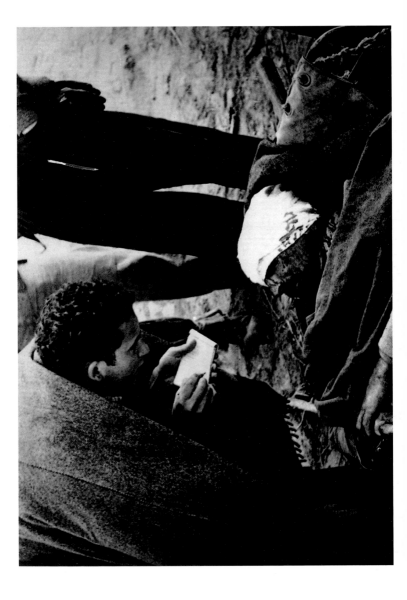

15. Mexico, July 7, 1940.

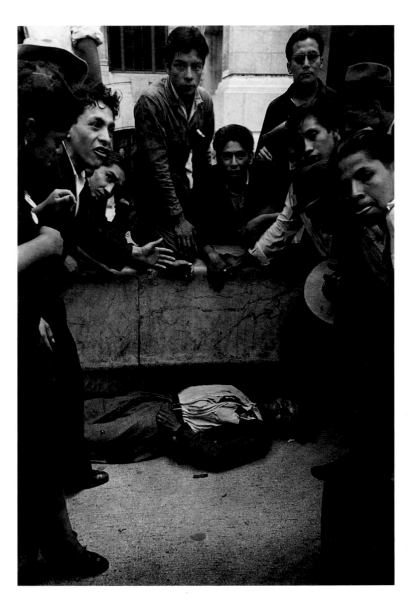

16. Spain, 1937.

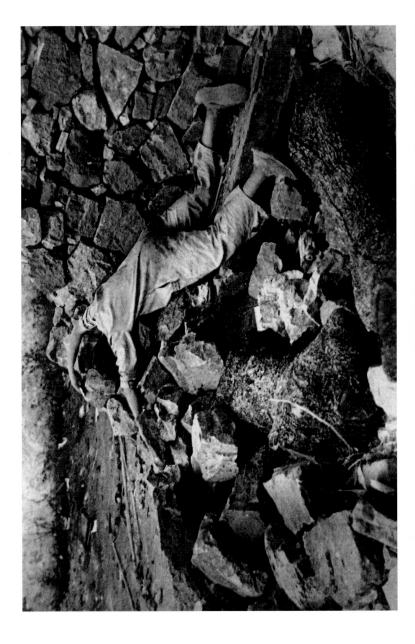

17. Bilbao, May 1937.

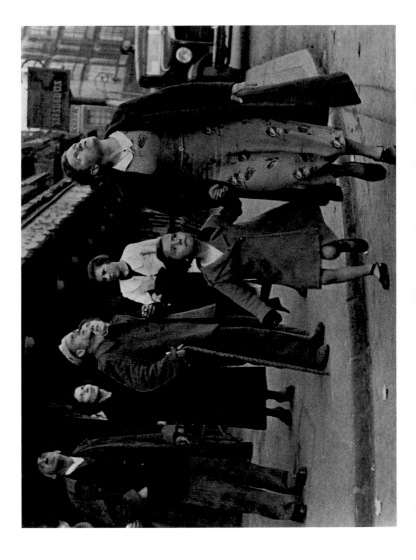

18. Bilbao, May 1937.

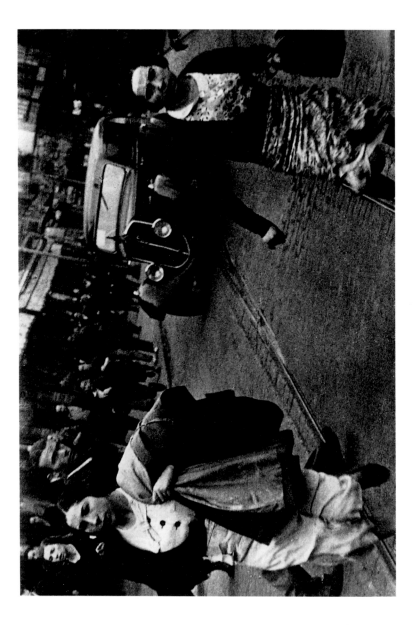

19. Madrid, 1936.

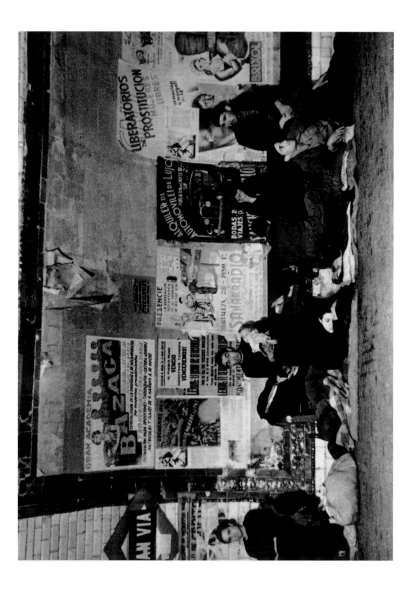

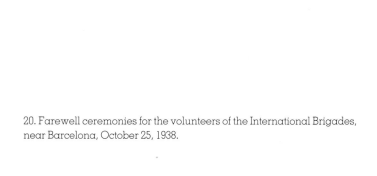

20. Farewell ceremonies for the volunteers of the International Brigades, near Barcelona, October 25, 1938.

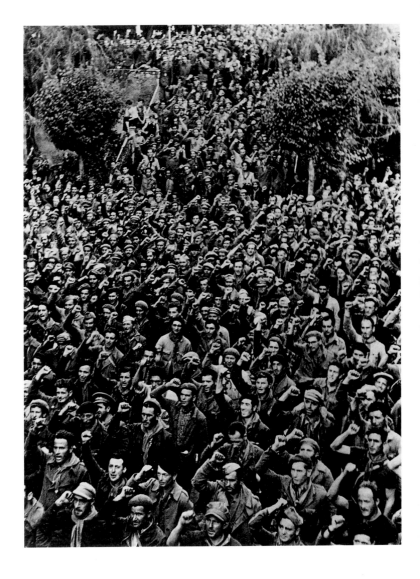

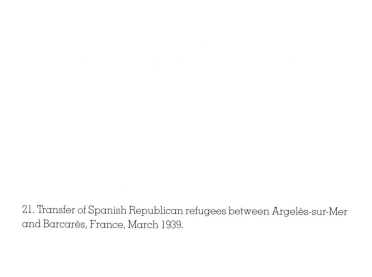

21. Transfer of Spanish Republican refugees between Argelès-sur-Mer and Barcarès, France, March 1939.

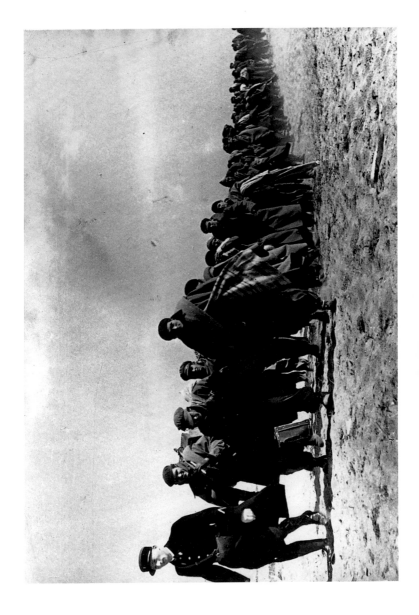

22. China, near the Xuzhou front, April 1938.

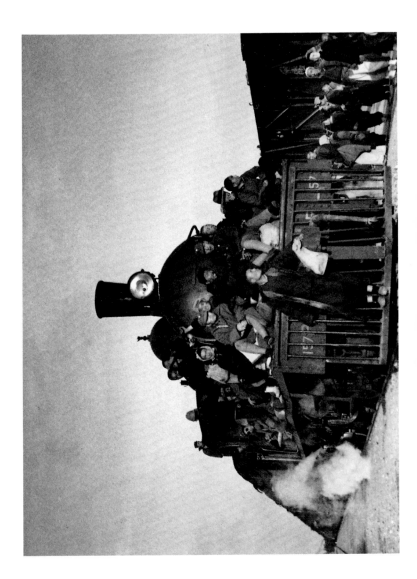

23. Canton, July–August 1938.

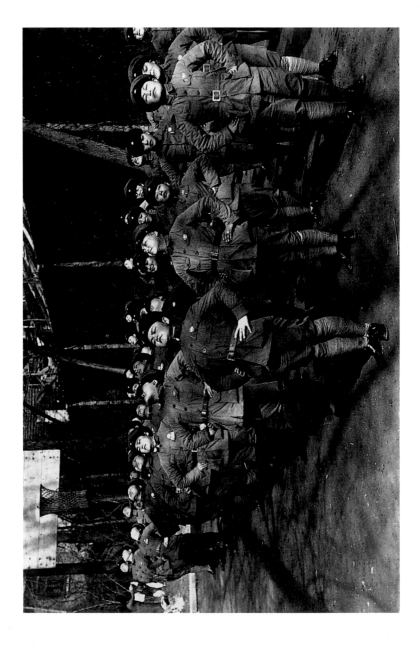

24. Ferryboat on the Yellow River, China, April–September 1938.

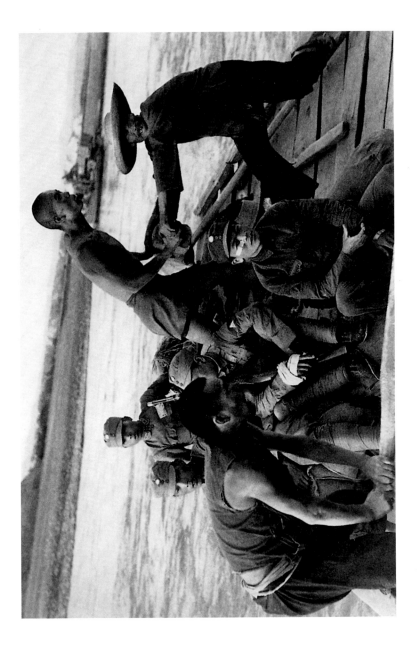

25. After an air raid, Hankow, China, July–September 1938.

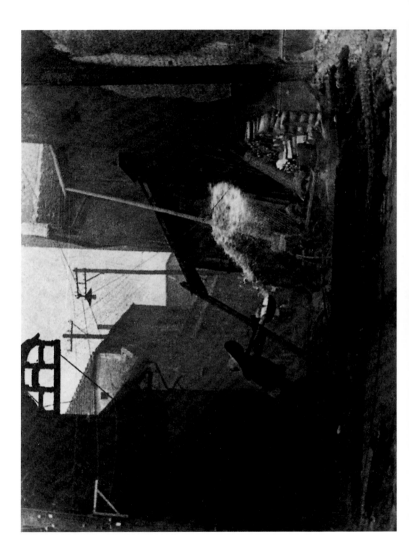

26. Hankow, China, July–September 1938.

Overleaf:
27 & 28. The Tour de France in Pleyben, Brittany, July 1939.

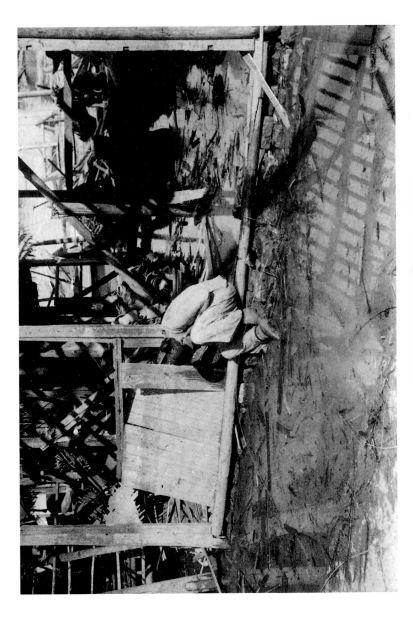

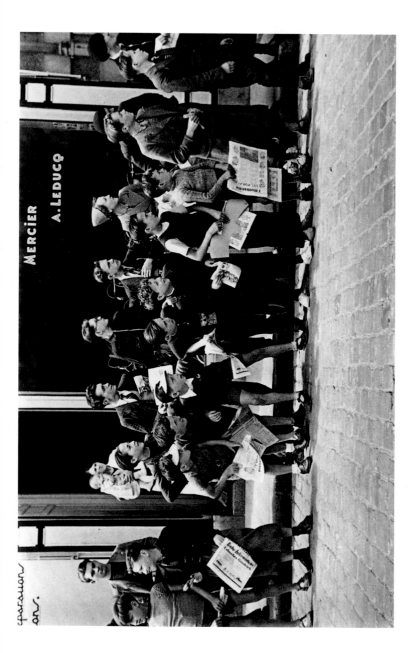

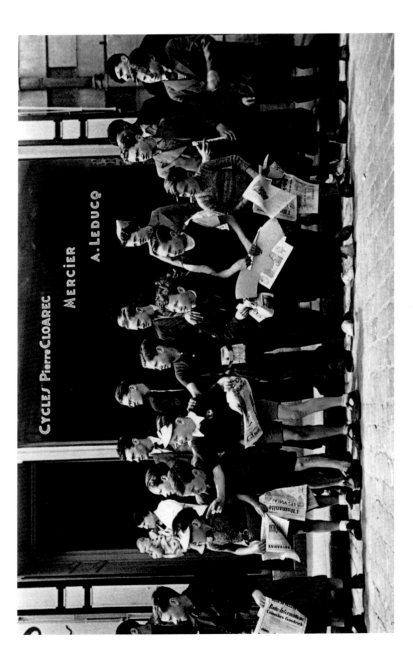

29. Calumet City, Illinois, December 1940.

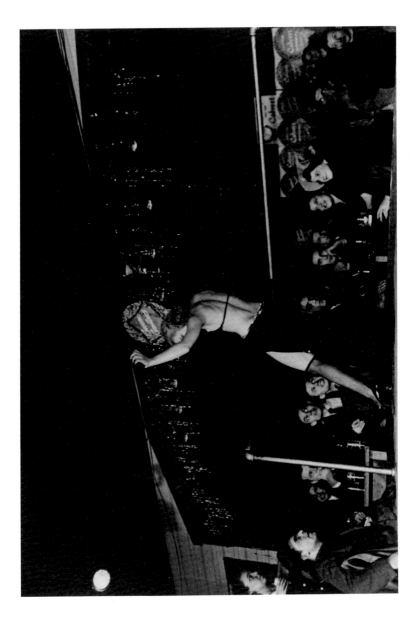

30. Italy, October 1943.

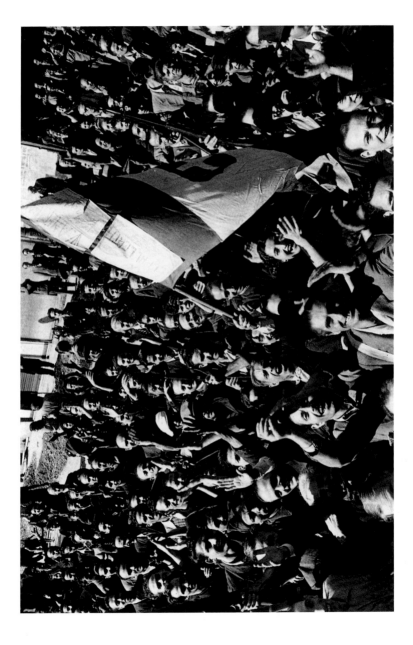

31. Troina, Sicily, August 6, 1943.

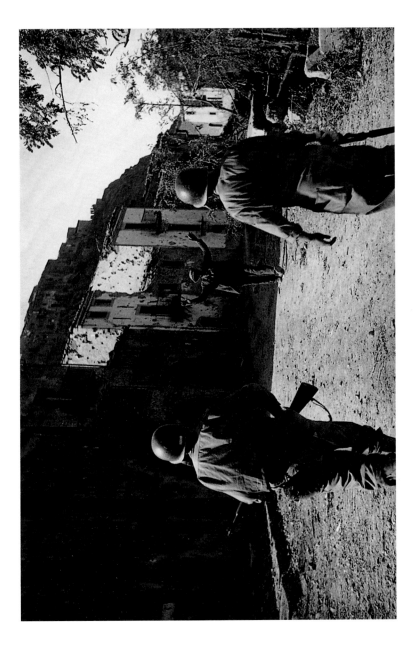

32. Monreale, Sicily, 1943.

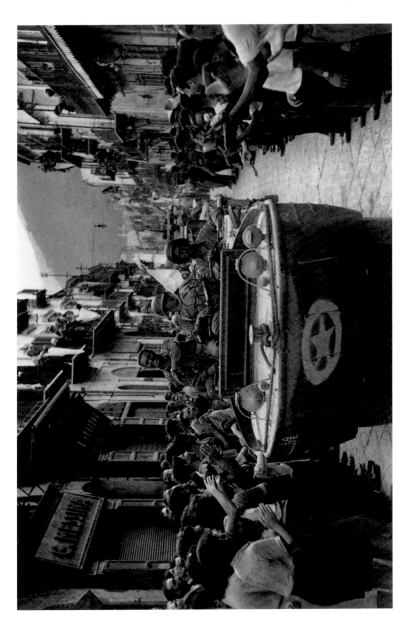

33. On the road from Naples, about September 30, 1943.

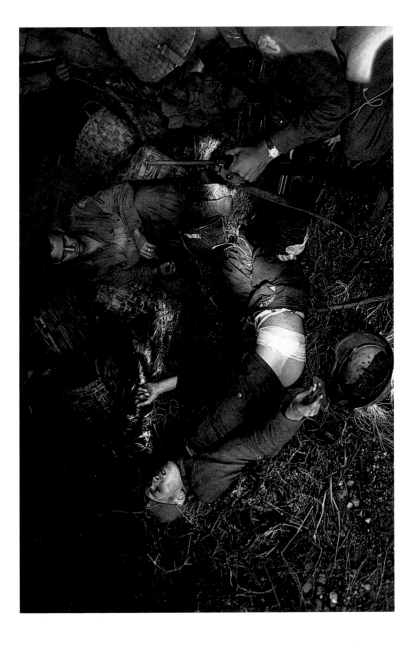

34. Sicily, 1943.

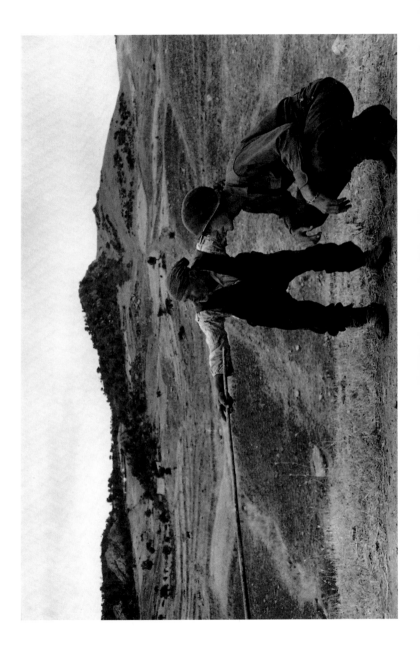

35. Funeral of teenage partisans who fought against the Germans, just before the arrival of the Allies, Naples, October 2, 1943.

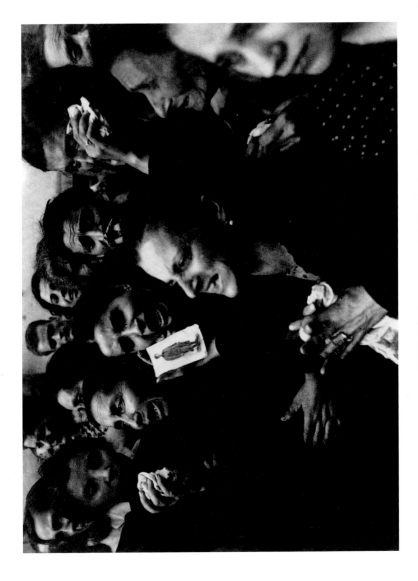

36. Naples, October 2, 1943.

Overleaf:
37 & 38. Landing of American troops on the Normandy coast,
Omaha Beach, June 6, 1944.

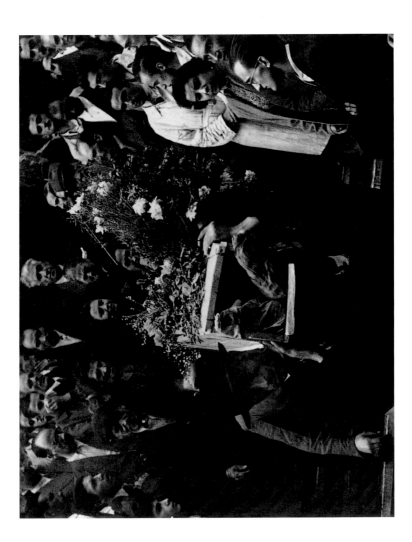

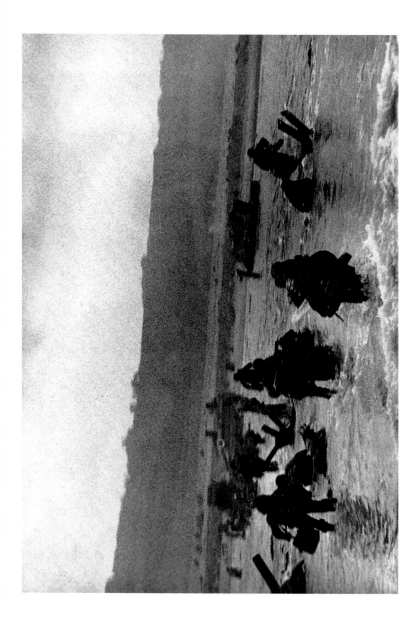

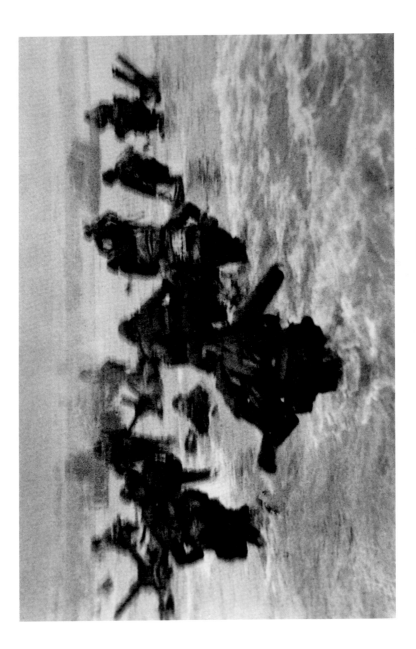

39. Omaha Beach, June 6, 1944.

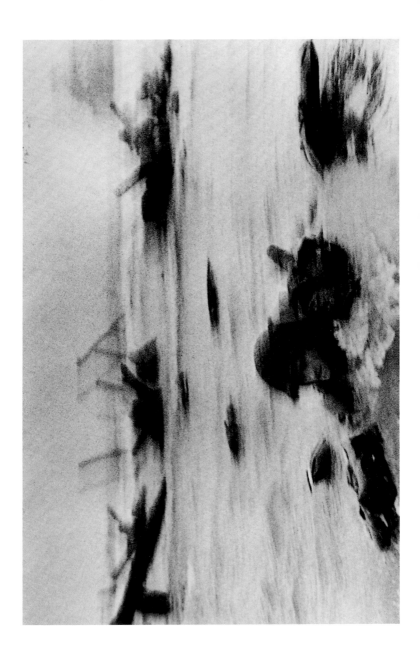

40. After the landing, Omaha Beach, June 1944.

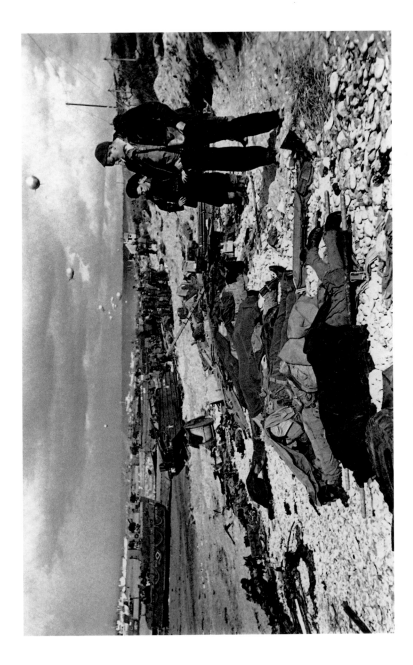

41. Notre-Dame-de-Cenilly, southwest of Saint-Lô, July 28, 1944.

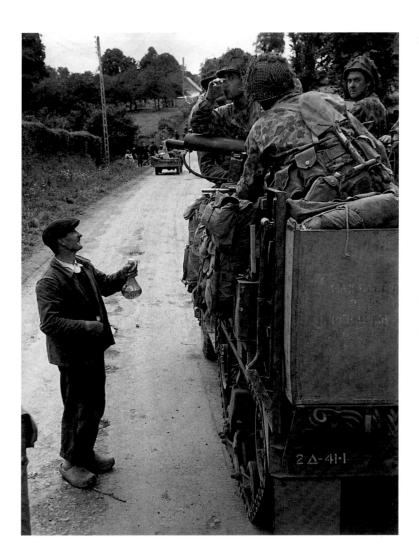

42. Normandy, July 26–30, 1944.

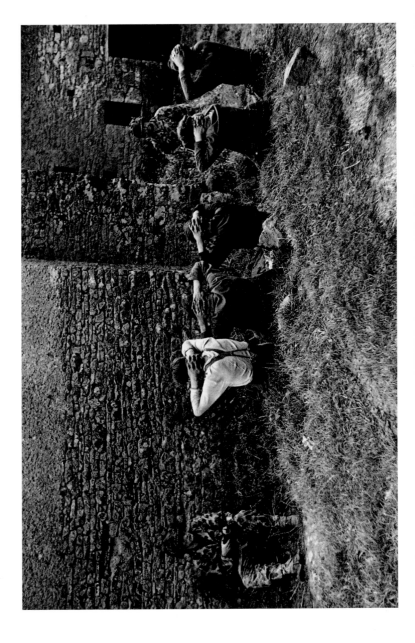

43. Paris, August 25, 1944.

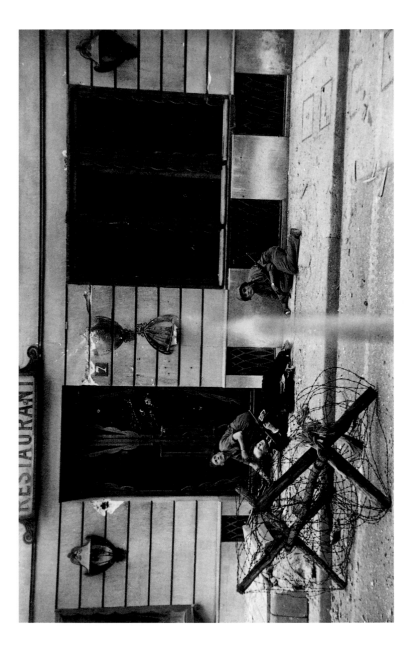

44. Chartres, August 18, 1944.

Overleaf:
45. Chartres, August 18, 1944.

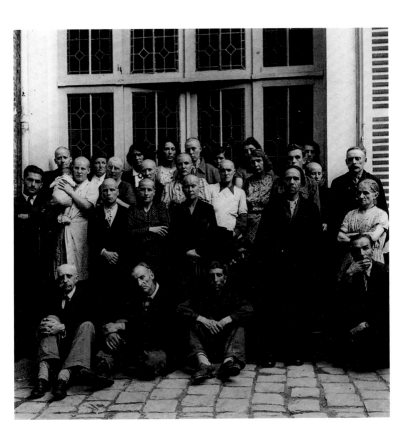

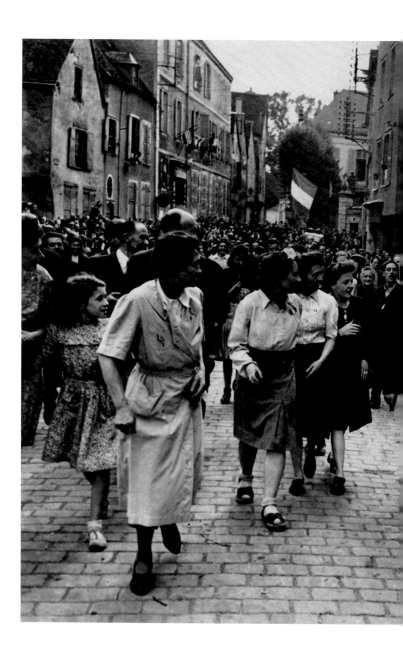

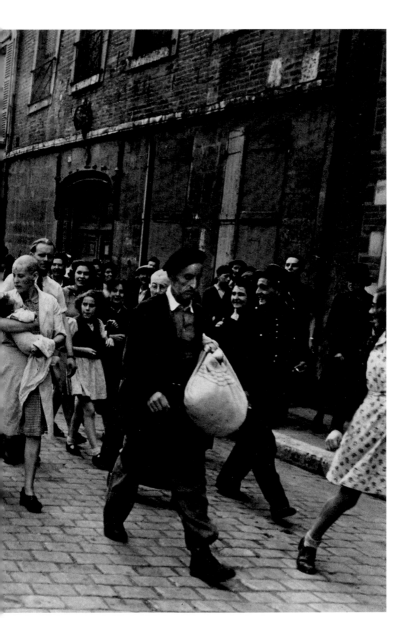

46. Paris, August 25, 1944.

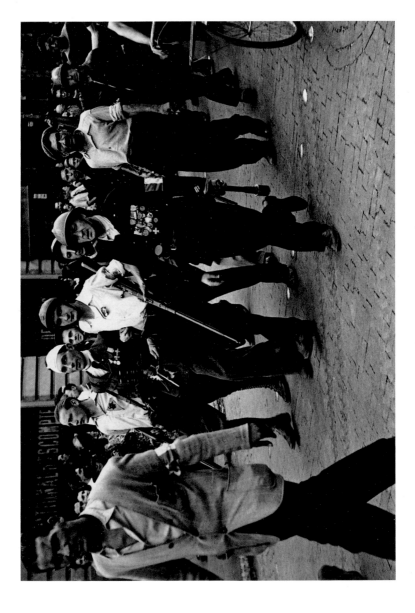

47. Paris, August 26, 1944.

Overleaf:
48. Paris, August 26, 1944.

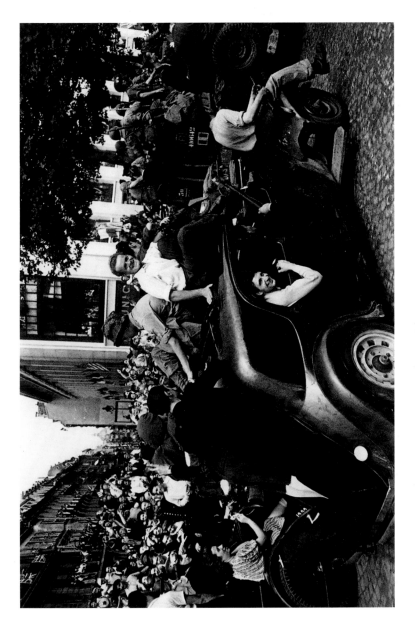

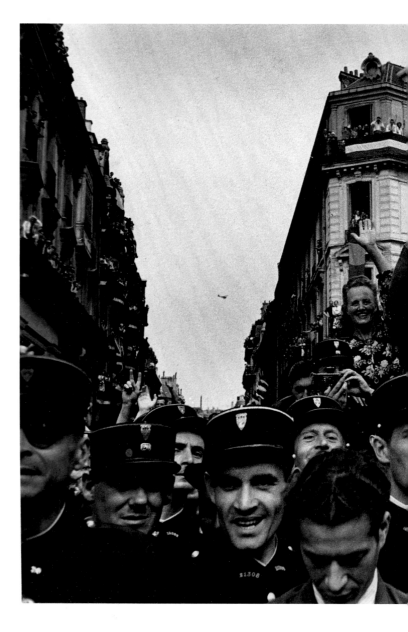

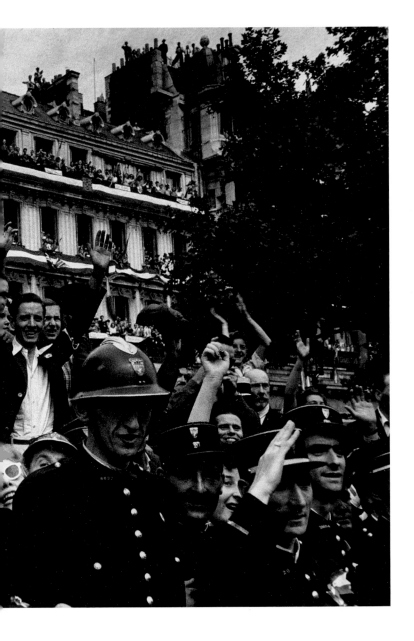

49. Paris, August 26, 1944.

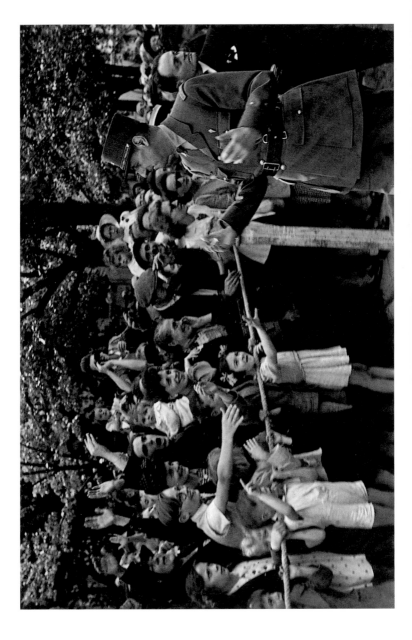

50. Alençon, August 12, 1944.

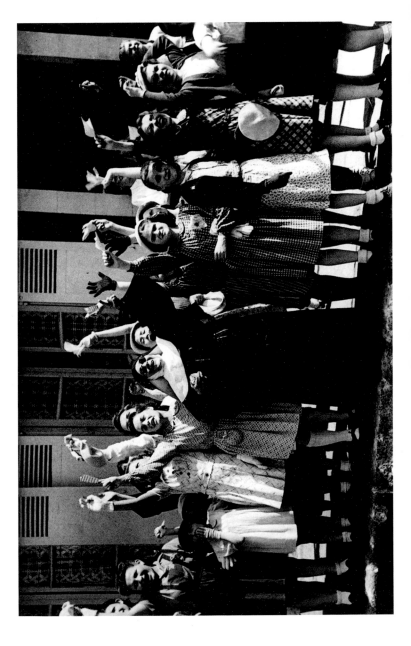

51. Germany, 1945.

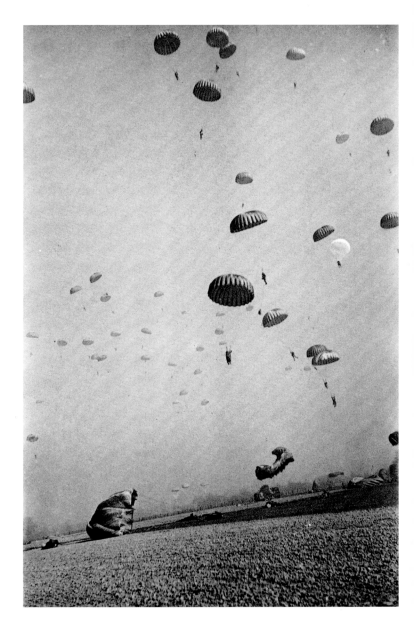

52. Belgium, south of Bastogne, December 23–26, 1944.

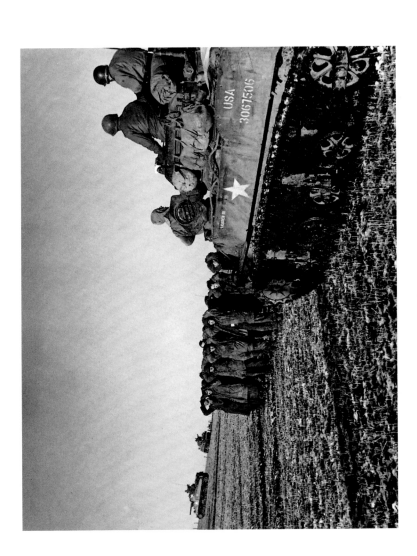

53. Germany, near Wesel, March 24, 1945.

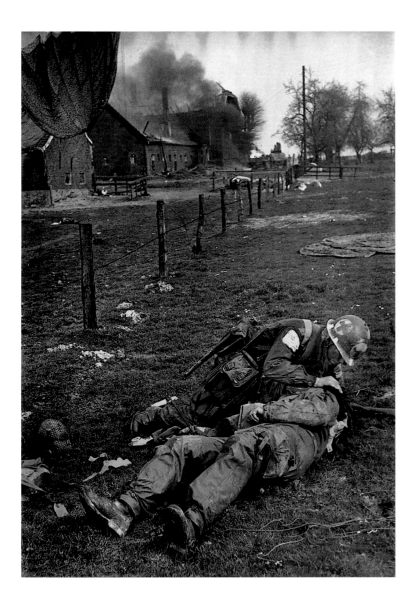

54. Germany, near Wesel, March 24, 1945.

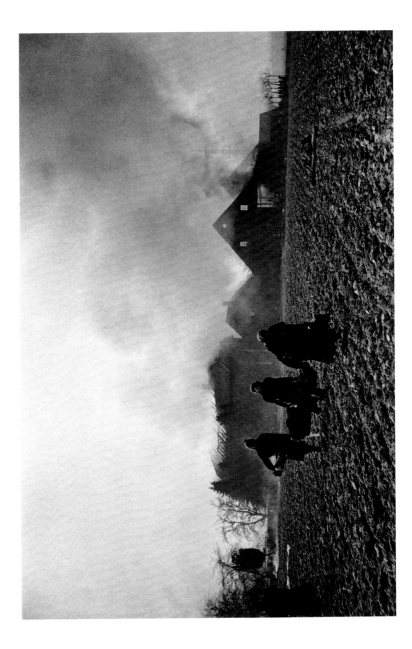

55. Ghetto ruins, Warsaw, October 1948.

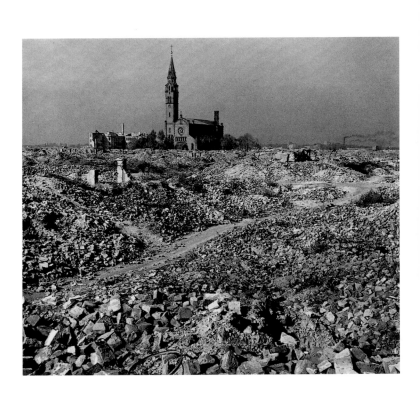

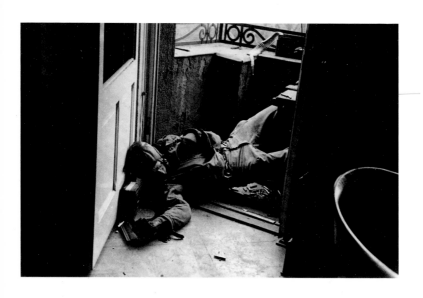

56–59. Death of an American soldier, Leipzig, April 18, 1945.

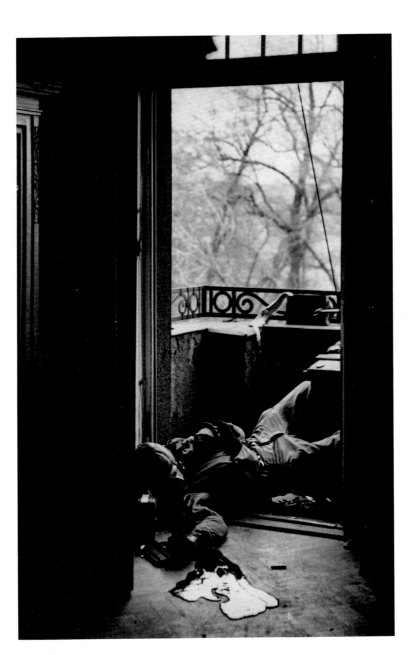

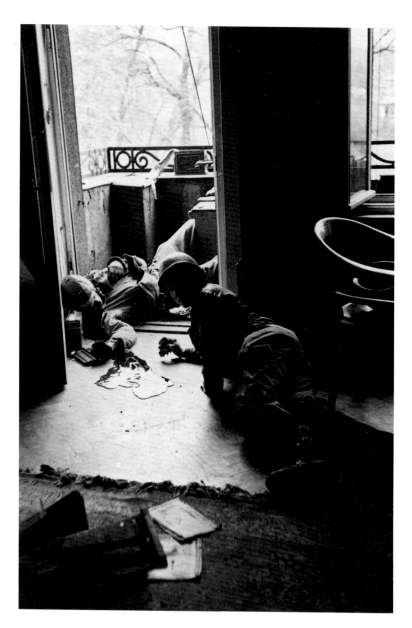

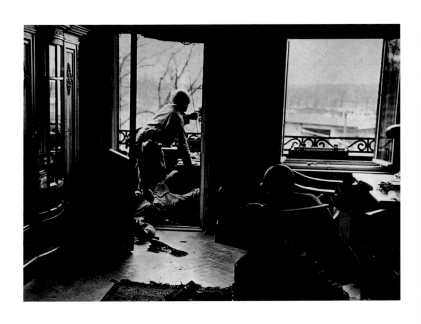

60. Refugee camp in Haifa, Israel, 1949.

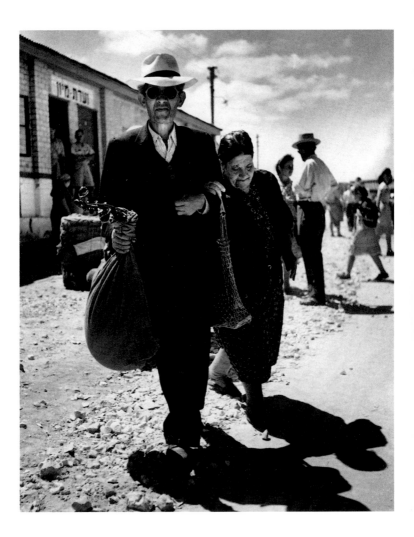

61. Refugee camp near Haifa, Israel, October –November 1950.

Overleaf:
62 & 63. Tel Aviv, June 22, 1948, and May 1949.

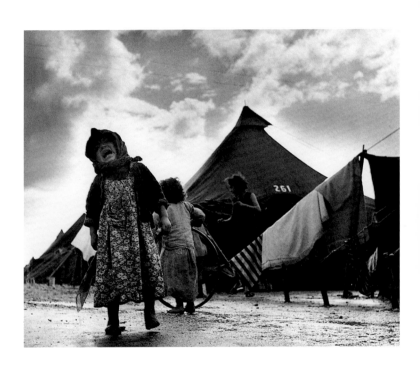

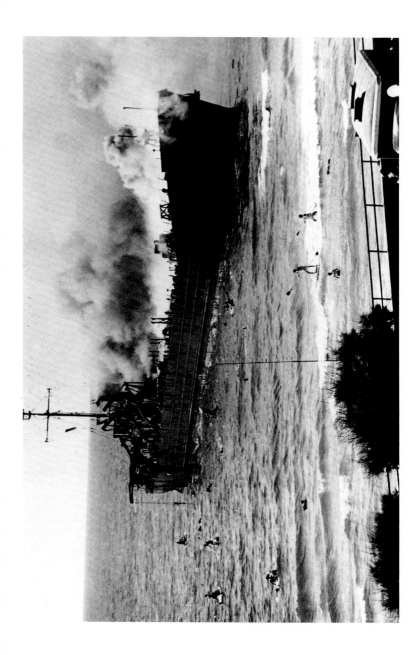

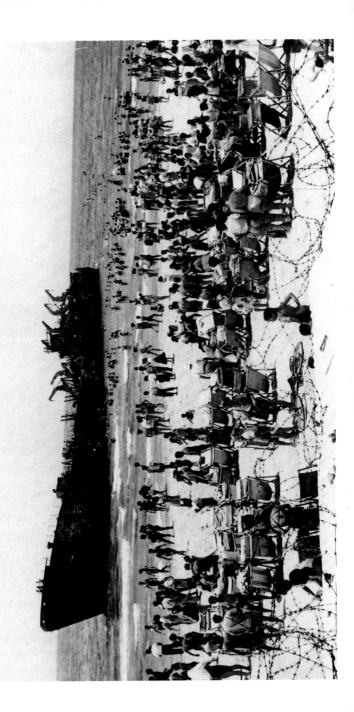

64. Village of blind immigrants, south of Tel Aviv, November–December 1950.

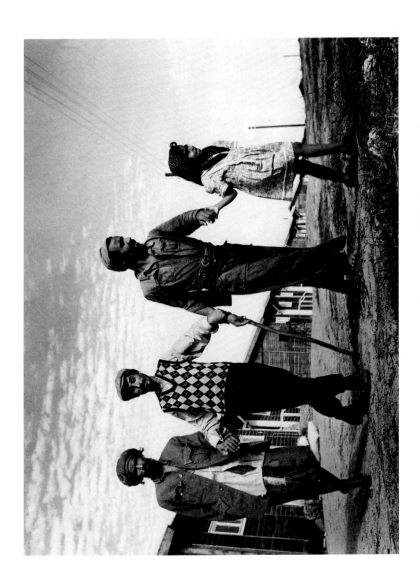

65. Nam Dinh, May 21, 1954.

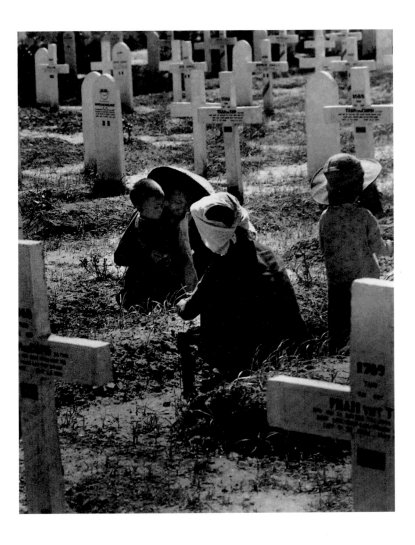

66. On the road to Thai Binh, Indochina, May 25, 1954.

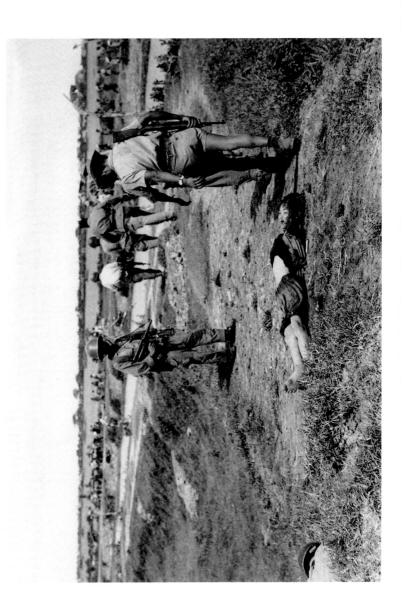

67. On the road to Thai Binh, Indochina, May 25, 1954.

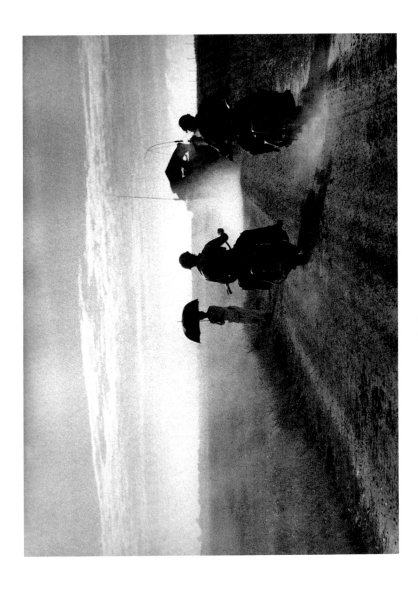

68. On the road to Thai Binh (Robert Capa's last photograph), Indochina,
May 25, 1954.

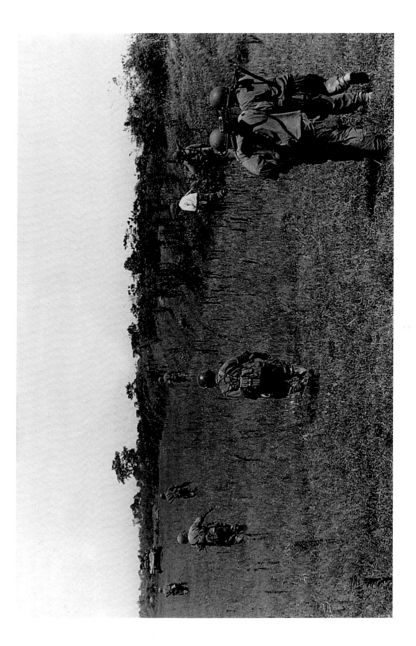

BIOGRAPHY

compiled by Stuart Alexander

1913 Born Endre Ernö Friedmann on October 22 in Budapest.

1930 Begins to photograph.

1931 Works as a photographer for Ullstein, Ltd., in Berlin, and for the Dephot photo agency.

1931–33 Studies political science at the Deutsche Hochschule für Politik in Berlin.

1933–35 Moves to Paris, where he struggles to find work. Meets Henri Cartier-Bresson, David "Chim" Seymour, and Gerda Taro. Makes countless contacts that will be invaluable to him later when starting the Magnum agency. Participates in the founding of the Alliance Photo Agency, run by Maria Eisner, who later became the secretary-treasurer of the fledgling Magnum agency. Takes the name André Friedmann.

1935 Takes the name Robert Capa and begins his collaboration with Gerda Taro.

1936 Photographs the Spanish Civil War. His work is published regularly in *Vu*, *Regards*, *Ce Soir*, *Weekly Illustrated* (London), *Life*, and various other magazines. Begins his career as a news photographer.

1937 Death of Gerda Taro in Spain.

1938 Works in China.

1939 Emigrates to the United States, where his mother lives in New York.

1941–45 Photographs World War II as a European correspondent for *Life* magazine. Throughout the war, his work appears regularly in the *Illustrated* (London) and *Collier's*.

1947 Receives the Freedom Medal from the U.S. Army. Starts Magnum Photos with Henri Cartier-Bresson, George Rodger, and Chim Seymour. Writes his first book, *Slightly Out of Focus*. Travels in Russia with John Steinbeck.

1948–50 Works in Israel.

1949 Shoots his first sequences for *Holiday* magazine.

1951 Becomes president of Magnum.

1954 Becomes a naturalized American citizen. While on assignment for *Life* magazine, steps on a landmine at Thai Binh in Indochina (Vietnam) and is killed. The French army posthumously awards him the Croix de Guerre.

1955 The Overseas Press Club and *Life* magazine establish the annual Robert Capa Prize.

Capa's archives are maintained by Magnum, and by the International Center of Photography in New York.

Robert Capa by Ruth Orkin.

SELECTED BIBLIOGRAPHY

Books by and about Robert Capa

Death in the Making, by Robert Capa. Photographs by Robert Capa and Gerda Taro, captions by Gerda Taro, preface by Jay Allen, art direction by André Kertész. New York: Covici-Friede, 1938

The Battle of Waterloo Road, by Diana Forbes-Robertson and Robert Capa. New York: Random House, 1941

Invasion!, by Charles Christian Wertenbaker. Photographs by Robert Capa. New York and London: Appleton-Century, 1944

Slightly Out of Focus, by Robert Capa. New York: Henry Holt, 1947

A Russian Journal, by John Steinbeck. Photographs by Robert Capa. New York: Viking, 1948

Report on Israel, by Irwin Shaw and Robert Capa. Photographs by Robert Capa. New York: Simon & Schuster, 1950

Robert Capa: War Photographs, by Jozefa Stuart. Introduction by John Steinbeck. Washington DC: Smithsonian Institution, 1960

Images of War, by Robert Capa. New York: Grossman, 1964. Also French, Italian, German and Japanese editions

Robert Capa. Edited by Anna Farova. Text by several authors. New York: Paragraphic Books/Grossman, 1969

Robert Capa, 1913–1954. Introduction by Cornell Capa. New York: ICP/Grossman, 1974

Front Populaire, by Robert Capa and David "Chim" Seymour. Text by Georgette Elgey. Paris: Chêne/Magnum, 1976

Capa: Emlèkkiállitás. Introduction by Ivan Boldiszár. Budapest: Mücsarnok, 1976

Robert Capa, by Romeo Martinez. Milan: Mondadori, 1979

Les Grandes Photos de la Guerre d'Espagne. Text by Georges Goria. Photographs by Robert Capa and David "Chim" Seymour. Paris: Jannink, 1980

Robert Capa. Tokyo: Pacific Press Service; New York: ICP, 1980

Robert Capa. Text by Anna Winand. Milan: Fabbri, 1983

Robert Capa: War and Peace. Tokyo: Pacific Press Service; New York: ICP, 1984

Robert Capa: Photographs. Edited by Richard Whelan and Cornell Capa. New York: Knopf, 1985

Robert Capa: A Biography, by Richard Whelan. New York: Knopf, 1985

Robert Capa. Barcelona: Fundació La Caixa, 1986

Robert Capa: Sommertage, Friedenstage: Berlin 1945. Edited by Diethart Kerbs. Photographs by Robert Capa. Berlin: Dirk Nishen/Verlag in Kreuzberg, 1986

Robert Capa: Cuadernos de Guerra en España (1936–1939). Edited by Carlos Serrano. Valencia: Sala Parpalló/IVEI, 1987

Fotografías de Robert Capa sobre la Guerra Civil Española. Text by Javier Jimenez Ugarte, et al. Madrid: El Viso, 1990

Juste un peu flou:, autobiographie et photos de Robert Capa. Text by Richard Whelan and Cornell Capa. Paris: Delpire Editeur, 2003

Robert Capa: l'homme qui jouait avec sa vie. Text by Alex Kershaw. Paris: J.C. Lattès, 2003

Capa in Turkey: Photographs of Turkey, 1946 (exhibition catalogue). Istanbul: YKK, 2003

Robert Capa connu et inconnu. Text by Laure Beaumont-Maillet et al. (exhibition catalogue). Paris: BNF, 2004

Robert Capa, l'oeil du 6 juin 1944. Paris: Gallimard, 2004

Robert Capa: D-Day. Preface by John Morris, text by Benoît Eliot and Stéphane Rioland. Rouen: Point De Vues, 2004

Robert Capa: Photographs. Foreword by Henri Cartier-Bresson. New York: Aperture, 2004

Heart of Spain: Robert Capa's Photographs of the Spanish Civil War. Text by Juan P. Fusi Aizpúrua and Richard Whelan. New York: Aperture, 2005

Capa's World: The Works of Robert Capa and his Life (exhibition catalogue). Tokyo: Tokyo Fuji Art Museum, 2006

This is War!: Robert Capa at Work. Text by Richard Whelan, Christopher Phillips, and Willis E. Hartshorn. Göttingen: Steidl; New York: ICP, 2007

Other books

The Concerned Photographer. Edited and with an introduction by Cornell Capa. Text by Robert Sagalyn and Judith Friedberg. New York: Grossman, 1968

Israel, The Reality: People, Places, Events in Memorable Photographs. Edited by Cornell Capa. Preface by Nelson Glueck. Introduction by Moshe Shamir. New York: World Publishing/The Jewish Museum, 1969

Photojournalism. Life Library of Photography, New York: Time-Life Books, 1971, pp. 66–67

Behind the Great Wall of China: Photographs from 1870 to the Present. Edited by Cornell Capa. Introduction by Weston J. Naef. New York: Metropolitan Museum of Art, 1972

Looking at Photographs, by John Szarkowski. New York: Museum of Modern Art, 1973, pp. 145–46

"Views of Paris: Notes on a Parisian," by Irwin Shaw. In *Paris/Magnum: Photographs 1935–81*. Introduction by Inge Morath. New York: Aperture, 1981, pp.11–17

"Death in the Making: Representing the Spanish Civil War," by David Mellor. In *No Pasarán! Photographs and Posters of the Spanish Civil War*. Bristol: Arnolfini Gallery, 1986, pp.24–43

Alliance Photo: agence photographique 1934–1940. Text by Marie de Thezy and Thomas Michael Gunther. Paris: Bibliothèque Historique de la Ville de Paris, 1988

Terre promise: quarante ans d'histoire en Israël. Edited with text by William Frankel. Introduction by Abba Eban. Paris: Nathan Image, 1988

China, A Photohistory, 1937–87. London: Thames & Hudson; New York: Pantheon, 1988

In Our Time: The World As Seen by Magnum Photographers. Text by William Manchester, Jean Lacouture, Fred Ritchin, Stuart Alexander. New York: W.W. Norton, 1989

Magnum 50 ans de Photographies. Text by William Manchester, Jean Lacouture, Fred Ritchin, Stuart Alexander. Paris: Nathan Image, 1989

ICP: Twenty Years 1974–1994. Text by Cornell Capa, Vicky Goldberg. New York: International Center of Photography, 1989

Capa & Capa, Brothers in Photography. New York: ICP; Tokyo: Tokyo Fuji Art Museum, 1992

Magnum Cinéma: Des histoires de cinéma par les photographes de Magnum. Text by Alain Bergala. Paris: Cahiers du Cinéma / Paris Audiovisuel, 1994

El Compromiso de la Mirada: Imagenes de la Posguerra Europea, 1945–1962. Text by Marta Gili, Ute Eskildsen and Lluis Montreal. Barcelona: Fundació La Caixa, 1995

Focus on Humanity, A Century of Photography. Archives of the International Committee of the Red Cross. Geneva: Skira, 1995

Guerras fratricidas. Introduction by Régis Debray, Javier Tusell, José Maria

Mendiluce. Barcelona: Fundació La Caixa, 1996

Magnum Photos: Photo Poche. Paris: Nathan, 1997

Israel: 50 Years, As Seen by Magnum Photographers. New York: Aperture, 1998

Requiem: By the Photographers Who Died in Vietnam and Indochina. Text by Horst Faas and Tim Page. London: Random House, 1997

Photographes: Made in Hungary, Arles: Actes Sud; Milan: Motta, 1998

Combattre. Paris: Finest SA/Editions Pierre Terrail, 1999

La Guerre Civile Espagnole: Des photographes pour l'Histoire, Paris: Marval/Museo Nacional Catalunya, 2001

Magnum Stories. Edited by Chris Boot. London: Phaidon, 2005

Le Front Populaire: Photo Poche Histoire. Text by Jean Lacouture. Arles: Actes Sud, 2006

Magnum Magnum. London: Thames & Hudson, 2007

Magnum Photos: Photofile. London: Thames & Hudson, 2008

Periodicals

"Capa's Camera," *Time*, February 28, 1938

"This is War," *Picture Post*, vol. 1, no. 10. December 3, 1938. pp. 13–24

"Coal Mine Characters by Capa," *US Camera*, June 1943

"The Man Who Invented Himself," by John Hersey. *'47: The Magazine of the Year*, September 1947

"Women and Children in the USSR," by John Steinbeck and Robert Capa. *Ladies' Home Journal*, vol. 65, no. 2 (February 1948), pp. 44–59

"From the Rubble," by Theodore H. White. *Holiday*, vol. 5, no. 6 (June 1949), pp. 80–81, 83–86, 88–89, 142–145

"Robert Capa, Werner Bischof," by John G. Morris. *Infinity*, May 1954, pp. 3–7

"Adieu Capa," by Louis Aragon. *Les lettres françaises*, May 27–June 3, 1954

"A Farewell to Two Photographers: A Last Salute to Two Men," *Camera*, vol. 33, no. 6 (June 1954), pp. 283–84

"A Great War Reporter and His Last Battle," *Life*, vol. 36, no. 23 (June 7, 1954), pp. 27–30

"He Said: 'This Is Going to Be a Beautiful Story.' " by John Mecklin. *Life*, vol. 36, no. 23 (June 7, 1954), pp. 31–33

"Death Stops the Shutter," *Time*, June 7, 1954

"Capa and Bischof… They Were Two Great Photographers," *Photography* (London), vol. 9, no. 7 (July 1954), pp. 44–48 (see also pp. 22, 24)

"Robert Capa, 1913–1954/Werner Bischof, 1915–1954," by Jacquelyn Judge. *Modern Photography*, vol. 18, no. 8 (August 1954), pp. 42–43, 87–88

"Robert Capa: An Appreciation," by John Steinbeck. *Popular Photography*, vol. 35, no. 3 (September 1954), pp. 48–53

"A Man Named Capa," by Al Silverman. *Saga*, February 1958, pp. 22–25, 72–75

"Robert Capa," by Nelson Gidding. *Camera*, vol. 40, no. 3 (March 1961), pp. 5–25. Text by John Steinbeck and Ernest Hemingway

"The Many Faces of War," *New York Times Magazine*, April 19, 1964, pp. 30–31

"Images of War: Robert Capa: A Review," by W. Eugene Smith. *Infinity*, vol. 13, no. 7 (July 1964), pp. 4–10

"Robert Capa," *Camera*, vol. 48, no. 5 (May 1969). pp. 2–8

"Omaggio a Bob Capa," by Lanfranco Colombo. *Fotografia Italiana*, no. 173 (June 1972), pp. 18–64. Text by Piero Berengo Gardin

"Robert Capa," *Creative Camera*, no. 108 (June 1973), pp. 190–201

"My Friend Capa," by György Markos. *The New Hungarian Quarterly*, Winter 1976

"Capa: le mythe vivant," *Photo* (Paris), no. 143 (August 1979), pp. 48–59, 109

"Les amis de Capa: Gary Cooper et Hemingway vus par Robert Capa lors du tournage de *Pour qui sonne le glas*," *Photo* (Paris), no. 155 (August 1980), pp. 14–21, 81

"Forgotten Pictures of the Spanish Civil War: Photographs by Robert Capa, David Seymour and Gerda Taro," by Arthur Goldsmith. *Camera Arts*, vol. 1, no. 2 (March/April 1981), pp. 111–14. Article on the photo of the death of a Spanish soldier

"Robert Capa: 124 photos retrouvées," *Photo* (Paris), no. 189 (June 1983), pp. 72–85, 114

"The Capa Caper," by David Markus. *American Photographer*, vol. 2, no. 4 (October 1983), pp. 90–95

"Robert Capa," *Photo Japan* (Tokyo), no. 005 (March 1984), pp. 123–45

"Capa: The Man Behind the Myth," by Richard Whelan. *American Photographer*, vol. 15, no. 4 (October 1985), pp. 43–57

"Capa par Capa," *Photo* (Paris), no. 217 (October 1985), pp. 90–97, 136

"Essay-Review," by Steve Cagan. *Exposure* (Society for Photographic Education), vol. 24, no. 2 (Summer 1986), pp. 36–42

"The Capa Cache," by Randy Kennedy, *New York Times*, 27 January 2008

"La folle odyssée des négatifs de Capa," by Françoise Dargent, *Le Figaro*, 31 January 2008

"Belle découverte de négatifs de Capa," by Michel Lefebvre, *Le Monde*, 29 January 2008

SELECTED EXHIBITIONS

Solo exhibitions

1952 *On Picasso*, Museum of Modern Art, New York. (With Gjon Mili.)

1960 *Robert Capa: War Photographs*, Smithsonian Institution, Washington DC. (Traveling exhibition which went around the world, 1960–1965.)

1964 *Images of War*, Smithsonian Institution, Washington DC.

1966 *A Magyar Fotomüvészet 125-év*, Magyar Nemzeti Galéria, Budapest.

1976 *Capa: Emlèkkiállitàs*, Budapest Mücsarnok, Budapest.

1980 *Robert Capa*, Tokyo.

1982 *Robert Capa: War and Peace*, Tokyo.

1985 *Robert Capa: Photographs*, ICP, New York.

1986 Fundació La Caixa de Pensions, Barcelona.

1987 *Robert Capa: Cuadernos de guerra en España (1936–1939)*, Sala Parpalló, Valencia, Spain.
Galerie Municipale du Château d'Eau, Toulouse.

1989 *Robert Capa: Retrospectiva, 1932–1954*, Fundació La Caixa de Pensiones, Barcelona.

1991 *Children of War, Children of Peace: Photographs by Robert Capa*, ICP, New York.

1991–92 *Robert Capa: A Retrospective*, Sala de Exposiciones de la Diputación Provincial de Burgos, Spain; Museo de Bellas Artes, Caracas, Venezuela.

1997 *Capa's Life: Robert Capa Retrospective Exhibition*, Tokyo Fuji Art Museum, Tokyo.

1999 *Heart of Spain. Robert Capa's Photographs of the Spanish Civil War*, Museo Nacional Centro de Arte Reina Sofía, Madrid.

2000 *Robert Capa: Photographs*, Helsinki City Art Museum, Finland.

2002 *Israël 1948–1950*, Musée d'Art et d'Histoire du Judaïsme, Paris.

2003 *Capa in Turkey*, Yapi Kredi Cultural Center, Istanbul.

2004 *Robert Capa connu et inconnu*, Bibliothèque Nationale de France, Site Richelieu, Paris.

2005 *Robert Capa: Retrospective*, Martin-Gropius-Bau, Berlin. *Robert Capa's Photographs*, Hungarian Museum of Photography, Budapest.

2007 *This is War! Robert Capa at Work*, International Center of Photography, New York.

Group exhibitions

1951 *Memorable Life Photographs*, Museum of Modern Art, New York.

1955 *The Family of Man*, Museum of Modern Art, New York.

1960 *The World As Seen by Magnum Photographers*, Smithsonian Institution, Washington DC.

1964 *The Photographer's Eye*, Museum of Modern Art, New York.

1968 *The Concerned Photographer*, Riverside Museum, New York.

1969 *Israel: The Reality*, Jewish Museum, New York.

1972 *Behind the Great Wall of China*, Metropolitan Museum, New York.

1973 *Looking at Photographs*, Museum of Modern Art, New York.

1974 *The Classics of Documentary Photography*, International Center of Photography, New York.

1981 *Spain 1936–1939*, International Center of Photography, New York.

1986 *No Pasarán: Photographs and Posters of the Spanish Civil War*, Arnolfini Gallery, Bristol.

1992 *Capa & Capa, Brothers in Photography*, International Center of Photography, New York; Tokyo Fuji Art Museum, Tokyo.

2001 *The Spanish Civil War*, Museu Nacional d'Art de Catalunya, Barcelona

2007 *Turkey by Magnum*, Istanbul Modern, Istanbul. *Paris en couleurs*, Hôtel de Ville, Paris.

FILMS

1938 *The Four Hundred Million*, by Joris Ivens. (Capa was the second cameraman.)

1946 *The March of Time* (Turkey). Direction: Robert Capa. Photography: Paul Martellière.

1948 8 films on Paris fashion. World Video, New York.

1948 *The Journey* (on Israel). United Jewish Appeal, New York. Direction: Robert Capa. Production: John Fernhout. Photography: Jacques Letellier.